SkiraMini**ART**books

D0862652

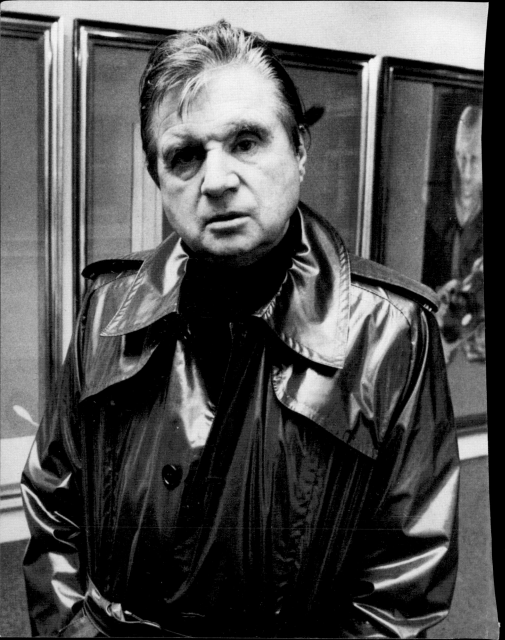

Francesca Marini

FRANCIS
BACON

front cover
Three Studies of Henrietta Moraes
(central panel), 1969
Oil on canvas, 35.5 x 30.5 cm
Private collection

Skira editore
SkiraMiniARTbooks

Editor
Eileen Romano

Design
Marcello Francone

Editorial Coordination
Giovanna Rocchi

Layout
Anna Cattaneo

Iconographical Research
Alice Spadacini

Editing
Maria Conconi

Translation
Richard Pierce, Verona

First published in Italy in 2008
by Skira Editore S.p.A.
Palazzo Casati Stampa
via Torino 61
20123 Milano
Italy

www.skira.net

Printed and bound in Italy.
First edition

ISBN 978-88-6130-709-4

Distributed in North America by
Rizzoli International Publications,
Inc., 300 Park Avenue South,
New York, NY 10010.
Distributed elsewhere in the world
by Thames and Hudson Ltd.,
181a High Holborn, London
WC1V 7QX, United Kingdom.

facing title page
Francis Bacon in a photograph
of *circa* 1975 (detail)

© 2008, Digital image,
The Museum of Modern Art,
New York / Scala, Firenze
© The Estate of Francis Bacon,
by SIAE 2008
© Hulton-Deutsch Collection /
Corbis / Contrasto
Archivio Skira

Contents

Francis Bacon

Francis Bacon was born in Ireland of English parents in 1909. Because of his homosexuality, when he was seventeen he was sent away from home and moved to London. In 1926 and 1927 he visited Berlin and Paris with one of his uncles, the brother of his mother. The first city proved to be the site of absolute liberation for the artist: "There was something extraordinarily free and wide open everywhere", the artist later said. After the austere architecture of Berlin, the elegance and vivaciousness of Paris impressed Bacon so much that he paid regular visits to that city for the rest of his life, and even settled there for a certain period. The heritage of the visual and cultural experiences he gained in the two capital cities led to his encounter with the art of Pablo Picasso – whose works would be a constant point of reference for years and the main driving force behind his first drawings – as well as with avant-garde cinema: Eisenstein's *The Battleship Potëmkin*, *Metropolis* by Fritz Lang, Abel Gance's *Napoleon* and lastly Luis Buñuel, who had just begun a career as a cinema critic in Paris and who in early 1929 returned to Spain to work with Salvador Dalí on the film *Un chien andalou*. As Buñuel later explained, if Surrealism had not existed, this film would never have been made and the image of the razor blade cutting an eye, which was the main theme of the film, would not have been one of the most shocking and provocative in the history of the cinema.

Bacon's acquaintance with the works of these film directors was a milestone in the development of his artistic style, as much as, or even more than Picasso's figurative works of classical inspiration, because of the capacity that cinema had to stir the senses, confuse and upset, while at the same time maintaining its concep-

tual and figurative rapport with painting and literature by means of the Surrealist aesthetic, which was also an indispensable outlet for the artist's early career.

Francis Bacon never studied at an art school and it was the Australian painter Roy de Maistre who provided him with his only formal training.

After the initial difficulties in making his way as an artist – he began to exhibit as part of the Young British Artists group in London, and then virtually abandoned painting for almost ten years – it was only in 1948, thanks to the purchase of one of works on the part of the Museum of Modern Art, that he began a successful career.

Three Studies for Figures at the Base of a Crucifixion (central panel), 1944
Oil and pastel on hardboard, 94 × 74 cm
The Tate Gallery, London

In 1944 Bacon finished a painting he had begun a few years earlier. This was his *Three Studies for Figures at the Base of a Crucifixion*, three distinct paintings conceived as a single work, a triptych whose common denominator is the brilliant orange of the walls of the three windowless rooms whose perspective has been altered, each of which contains a distorted image that is a combination of human and animal forms.

For the first time Bacon had adapted the Crucifixion motif to the format of the triptych, thus inducing critics to look into a possible relationship between the artist and religiosity. But he himself soon declared there was no connection between his oeuvre and any religious meaning, pointing out that the theme may have inspired him because of the theme of a suffering body on a cross. As for the choice of the triptych format – which would be used in many of

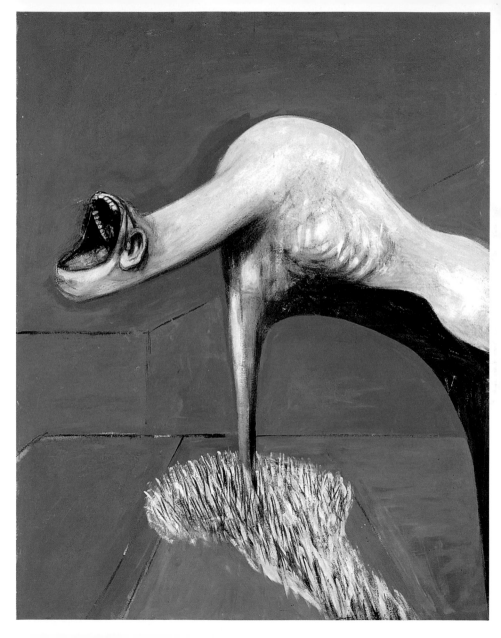

"It needs a sort of moment
of magic to coagulate colour
and form so that it gets
the equivalent of appearance.
In a second you may blik your
eyes or turn your head slightly,
and you look again and
the appearance has changed."

his future works – he stated that he was not sure one should speak of triptychs in his case. Yes, there were three canvases, and this could certainly be connected to the Old Masters tradition, and the so-called primitives often used this format, but Bacon said that in his case a triptych corresponded more to the idea of a sequence of images on a film, adding that he often used three canvases, but that he could very well have added others.

In most of Bacon's triptychs the three panels do not suggest any temporal sequence; in fact, they can be "read" in any order. This is the reason why, when during an exhibition the three parts were mounted together, the artist demanded that the frame be changed, since the three had to be mounted separately. "… It ruins the balance putting them together, because, if I'd wanted to do that, I would have painted them a different way", he said in the early 1970s.

Time in progression, the basic element in the narration of an event, was always strongly denied by the artist, who in one of his conversations with the critic David Sylvester offered the following as an explanation of his stance: "I don't want to avoid telling a story, but I want very, very much to do the thing that Valéry said – to give the sensation without the boredom of its conveyance. And the moment the story enters, the boredom comes upon you."

In April 1945, the *Three Studies of Figures at the Base of a Crucifixion* were exhibited together with another painting titled *Figure in a Landscape* at the prestigious Lefevre Gallery, in New Bond Street, London, where Bacon had been invited along with other contemporary British artists. The public's reaction to the three paintings was exactly what he had hope for: "(…) Half-human, half-

animal (…) we had no name for them and we didn't know how to describe our feelings upon seeing them", wrote one of the spectators at the exhibition. And again: "I must confess I was so shocked and distressed by the Surrealism of Francis Bacon that I was quite happy to leave the exhibition." (*Apollo*, May 1945). However, the sensation and shock caused by his works did not prevent the critics from recognizing that Bacon had studied and developed Picasso's recent production, especially *Guernica*, until he finally attained his own personal artistic idiom.

*Three Studies
for a Crucifixion*
(left panel), 1962
Oil and sand on canvas,
198.2 × 144.8 cm
Solomon R. Guggenheim
Museum, New York

Another young artist exhibited his works at the Lefevre Gallery show: Graham Sutherland, whom Bacon had met when they both took part in an exhibition at Agnew's in Bond Street. Around 1945 his relationship with Sutherland become closer, and the latter, who was better known than Bacon and admired his art, introduced his friend to some leading figures of British artistic institutions, such as John Rothenstein and Kenneth Clark, which proved to be a turning point in his career. The support of Rothenstein, who at the time was Director of the Tate Gallery, paved the way for his retrospective show in 1962 – which, after the Tate, moved to Mannheim, Turin, Zurich and Amsterdam – and his meeting and friendship with Clark was no less fruitful. Sutherland was so insistent that the director of the National Gallery finally went to visit Bacon's studio while he was working on his *Painting 1946*. A short time later Erika Brausen of the Hanover Gallery purchased this work for what at the time was considered a high price, especially given the fact that the artist was not yet a well established figure in the art market. However, the gallery owner's

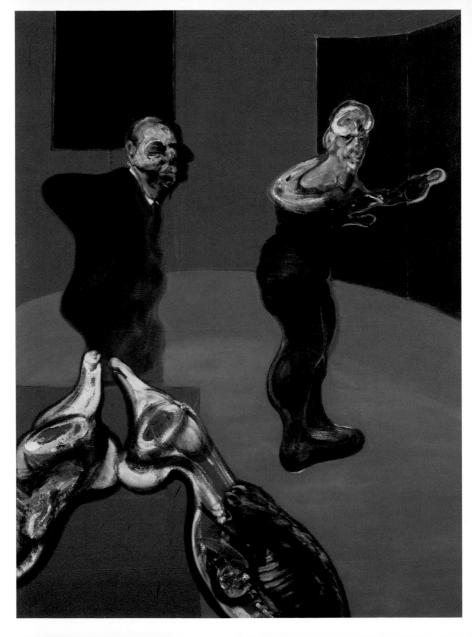

instincts proved to be right, for in 1948 she sold *Painting 1946* to Alfred J. Barr, who was responsible for the acquisitions of the Museum of Modern Art in New York. Brausen had also met Bacon through the good offices of Sutherland; moreover, in 1946 the painting had been chosen for the British section of the Paris International Exposition of Modern Art. During the first of the nine interviews Bacon had with David Sylvester for the BBC between 1962 and 1986, the artist explained how *Painting 1946* had been conceived and how long it had taken to finish: "Well, one of the pictures I did in 1946, the one like a butcher's shop, came to me as an accident. I was attempting to make a bird alighting on a field. And it may have been bound up in some way with the three forms that had gone before, but suddenly the lines that I'd drawn suggested something totally different, and out of this suggestion arose the picture. I had no intention to do this picture; I never thought of it that way. It was like one continuous accident mounting on top of another. (…) I don't think the bird suggested the umbrella; it suddenly suggested this whole image. And I carried it out very quickly, in about three or four days."

The great art critic Herbert Read noticed Bacon from the outset and included his *Crucifixion* next to a 1929 painting by Picasso in his book *Art Now: An Introduction to the Theory of Modern Painting and Sculpture*, published in 1933. Read noted that, in parallel with Sutherland, but with other means, Bacon had initiated the attempt to extract, from the human structure and from organic forms, images that represented their deepest sentiments, without illustrating their progression in any narrative form. Both artists

seemed to have revived the spare and gelid brutality of the last works of Walter Sickert, not without having taken in the British Surrealist experience of the Unit One group, and in particular of its promoter Paul Nash. At the beginning of the 1950s, Bacon was of the opinion that art was a means of liberating areas of feeling, going on to state: "I would like my pictures to look as if a human being had passed between them, like a snail, leaving a trail of the human presence and memory trace of past events, as the snail leaves it slime."

The means Bacon adopted to develop his style entailed the inclusion of sources that seem to reflect the heterogeneous expression that characterizes the twentieth century. The use made of material taken from photographs, newspapers, medical handbooks or even from the cinema – all combined, elaborated and refurbished – was a way of penetrating the depths of being, an act the artist performed during the execution of each work, and not in his mind beforehand.

Following pages
Three Studies
for a Crucifixion
(central and right panel),
1962
Oil and sand on canvas,
198.2 × 144.8 cm each
Solomon R. Guggenheim
Museum, New York

The Old Masters had always interested him quite a lot, beginning with the *Massacre of the Innocents* by Nicolas Poussin, which he had seen at the Chantilly museum and which he called "the best painting of a human cry." Indeed, his works, from the first series entitled *Heads* to the last paintings, were always in continuous dialogue with tradition.

He began first cycle of six *Heads* in 1948 and completed it the following year. The series was exhibited in November at Brauson's gallery and, except for the occasional criticism, the show was a great success. In the periodical *The Listener* Wyndham Lewis wrote:

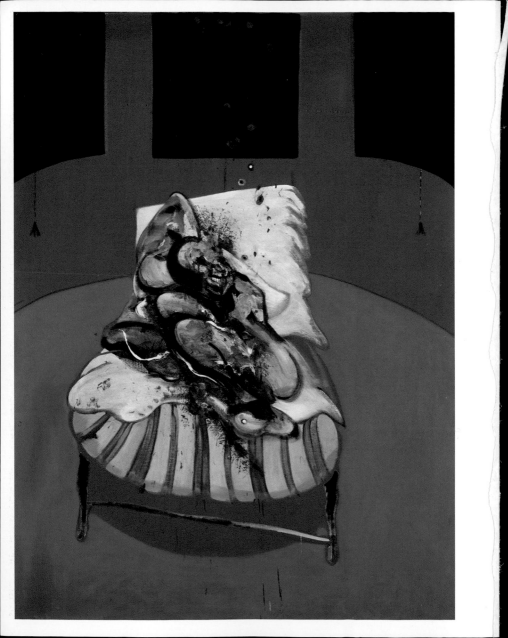

"I've always been very moved
by the movements of the mouth
and the shape of the mouth
and the teeth. People say that these
have all sorts of sexual
implications… I like, you may say,
the glitter and colour that comes
from the mouth, and I've always
hoped in a sense to be able to paint
the mouth like Monet painted
the sunset… And I've always wanted
and never succeeded in painting
the smile."

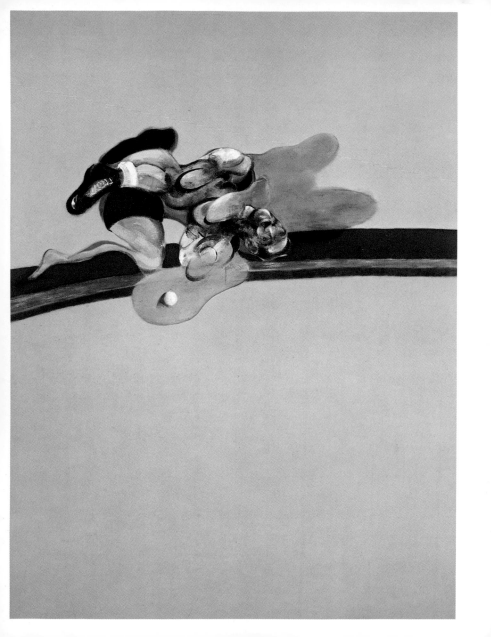

is placed in a large and dark background that isolates it and thus helps to lend it importance. An orderly series of long and broad grey brushstrokes begins beyond the semi-circular "frame" supporting a veiled "curtain" whose transparency allows us to see the podium. This brushwork was inspired by Bacon reading a book on the techniques of Cinerama movies, which explained how to soften the impact of the image.

Triptych – In Memory of George Dyer (left panel), 1971 Oil on canvas, 198.5 × 147.5 cm Fondation Beyeler, Riehen-Basel

I n 1961 Francis Bacon moved his studio to a small house at no. 7 Reece Mews in South Kensington. He often thought of moving again to a larger studio or even to another city, as when he decided to go to Paris to work in the mid-1970s. But up to the time he died he stayed in the two small rooms above the large garage where, since he had no automobile, he stored piles of books. A narrow wooden staircase much like those on a yacht led to the apartment. At the top, to the left, was a bare bedroom-living room, while at left was his small and chaotic studio, where fewer and fewer person were allowed to enter.

The home the artist was to live in for the rest of his life was extremely modest, surprisingly distant from his notorious taste for luxury. Even more striking was the contrast between the cleanliness and neatness of his perfectly tailored and ironed clothes, his carefully chosen and applied make-up and hair dye, and the total chaos that reigned in his small studio. The perfect recostruction of the atelier, which was put on display in Dublin in 2001, made it possible to count 7,500 items, consisting of drawings, photographs, illustra-

tions, books, catalogues, painting material, bits and pieces of destroyed paintings, and a host of odds and ends that the artist had purposely accumulated over the years. For Bacon his studio was like a chemist's laboratory, where one could not help imagining that an unexpected event would occur. Here he spent time with his friends, one of them probably being the sculptor Alberto Giacometti, whom Bacon had met in 1965 and with whom he had many conversations on art.

The artist's interviews and the precise reconstruction of his atelier reveal how he carefully selected — from among the rich and disorderly mixture of books, periodicals and photographs both old and new — only a few images that particularly stimulated and inspired him and that he sometime touched up, using them as the basis for a painting. The source of this creative process was contemporary life, represented by the vast and apparently disparate material he had kept; it was a repertory he could delve into to compare the works of past and modern masters such as Velázquez, as well as Michelangelo, Rembrandt, Ingres, and Van Gogh.

Ingres's influence on his production was quite different from that of Velázquez and Van Gogh. The canvas by Van Gogh that fired Bacon's imagination most was *The Painter on the Road to Tarascon*, kept in the Kaiser-Friedrich Museum in Magdeburg and destroyed during the Second World War. Bacon became acquainted with this work through a colour reproduction in a monograph on the Dutch artist by René Huyghe, a book that was found in Bacon's studio. What seemed to have so fascinated him was Van Gogh's capacity to succeed in being almost literal while at the same time offering a mar-

"I'm greedy for life; and I'm greedy
as an artist. I'm greedy for what
I hope chance can give me
far beyond anything that I can
calculate logically.
And it's partly my greed that
has made me what's called live
by chance – greed for food,
for drink, for being with the people
one likes, for the excitement
of things happening."

vellous vision of the reality of things through his painting technique. Bacon became conscious of this capacity during one of his stays in the south of France; "I saw it very clearly when I was once in Provence and going through that part of the Crau where he [Van Gogh] did some of his landscapes, and one just saw in this absolutely barren country that by the way he put on the paint he was able to give it such an amazing living quality, give that reality the Crau has of just plain, bare land." While in the case of Velázquez or Van Gogh, Bacon concentrated on only one painting, he tackled different subjects by Ingres. However, not all the latter's oeuvre interested Bacon to the same degree, as he once explained to Michel Archimbaud: "I'm very keen about some of Ingres's portraits and I also like *The Turkish Bath*, but for me there is no value in the history painting", which, however, was a fundamental part of the French artist's aesthetic.

Bacon had been passionate about classical antiquity at least from the time he met his friend Eric Hall in 1929, and many a time the artist spoke in his interviews of the impression the Aegina marble sculptures in the Munich Glyptothek had made on him. For Ingres, classical art and culture were by no means of secondary importance and therefore in several paintings he utilized the theme of Œdipus and the Sphinx, which Bacon also decided to work on.

The legend of Œdipus who solves the enigma of the Sphinx represented the triumph of human intelligence, and while Bacon's composition differed from the version of this theme that Ingres had painted in 1808, in *Œdipus and the Sphinx after Ingres* (Lisbon, The Berardo Collection – Sintra Museum of Modern Art), which he painted in 1983, he decided to change the "hierarchy" established by the French artist by placing Oedipus in an inferior position with respect

24

to the Sphinx, which he "humanized" with a person's head, adding to the composition the arrival of the Furies who burst onto the scene through the open door in the background, and depicting Oedipus as one of the boxers in the photographs of Muybridge and showing his bandaged leg, which according to the legend had been wounded during his infancy.

Following pages
Triptych – In Memory
of George Dyer
(central and right panel),
1971
Oil on canvas,
198.5 × 147.5 cm each
Fondation Beyeler,
Riehen-Basel

Besides the photographs, magazine, books, or individual illustrations torn out of various publications, Bacon also drew inspiration from, and elaborated, reproductions of certain works by the above-mentioned artists, which he compared to contemporary illustrations. This was the case with Michelangelo. In one of the conversations with Sylvester regarding the photographs of Muybridge and the works of Michelangelo, Bacon stated: "They are mixed up in my mind together", adding that he drew inspiration from the poses photographed by the former and power of the nudes of the latter. From the end of the 1940s on photography became increasingly important for Bacon, who later asked for shots of models before painting their portraits. John Deakin made many photographs of this kind for him. The artist had discovered Muybridge in the early 1950s at the Victoria and Albert Museum: he found his works particularly intriguing and congenial, and *Animals in Motion* and *The Human Figure in Motion* often provided him with "stimuli for new ideas." But Bacon was also interested in the entire history of photography, from Étienne-Jules Marey, Julia Margaret Cameron and Nadar to the contemporaries.

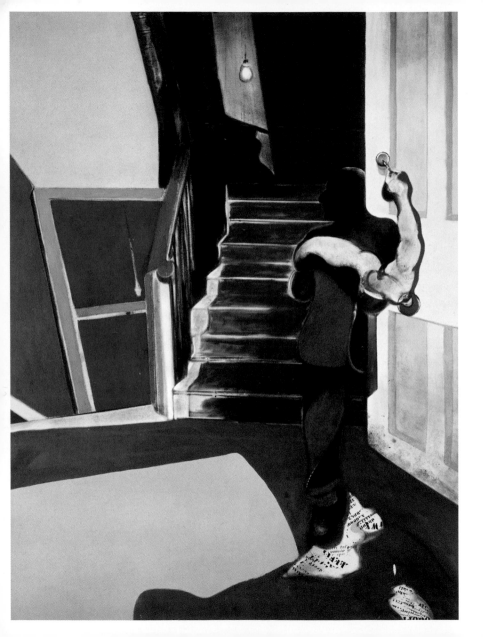

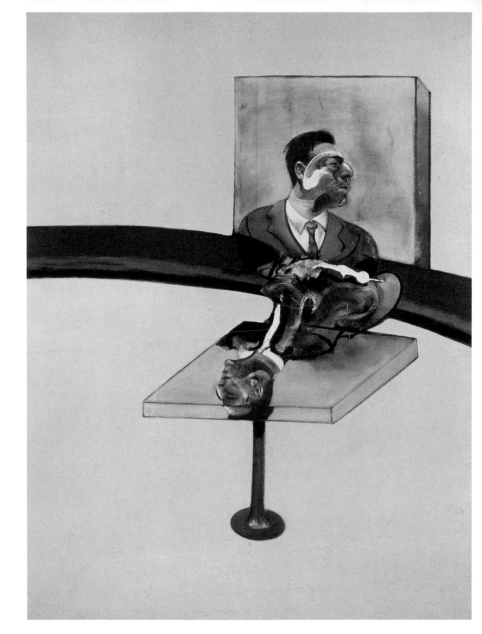

"It would be very difficult for me to disentangle the influence of Muybridge and the influence of Michelangelo. But, of course, as most of my figures are taken from the male nude, I am sure that I have been influenced by the fact that Michelangelo made the most voluptuous nudes in the plastic arts."

The open-ended and continuous dialogue with the great works of past, such as the Aegina marbles, Velázquez's *Portrait of Innocent X*, and the works of Ingres and Michelangelo, corresponded to an equally keen analysis and study that Bacon carried out on works of literature such as Greek tragedy, Samuel Beckett, the literary modernism of Thomas Stearns Eliot, and the visionary quality of William Blake, whose importance, above all as a poet, was also a decisive factor in the development of Sutherland's art. *Study for Portrait II* belongs to a group of works that derived precisely from Blake's "death mask", the cast for which was made in 1823, four years before the artist and poet died. These studies began after a composer, Gerard Schurmann, had set some of Blake's poems to music and asked the artist to create an image for the cover of the album. Bacon, who greatly admired Blake's poetry but not his painting, was interested enough in this project to go with the composer to the National Portrait Gallery of London to see the mask. He took many photos of the work and then returned several times to study it; in 1955 he executed numerous versions of the head, only five of which still exist.

Following pages
Three Studies of Figures
on Beds
(left and right panel), 1972
Oil and pastel on canvas,
198 × 147.5 cm each
Private collection

As in the photographs of the "death mask", the head stands against a uniformly dark backdrop. A few simple details suffice to lend expression to the face. The eyes are closed and out of alignment, while the outline of the nose is formed only by the shadow it creates. The wide mouth seems to be closed in a grimace of pain and the plastic quality of the head is made more evident by the clearcut diagonal mark that traverses one cheek, linking the ear and the edge of the turned downwards lips.

29

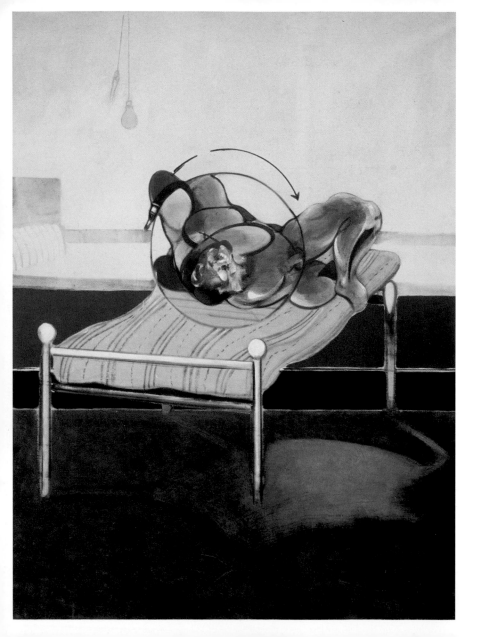

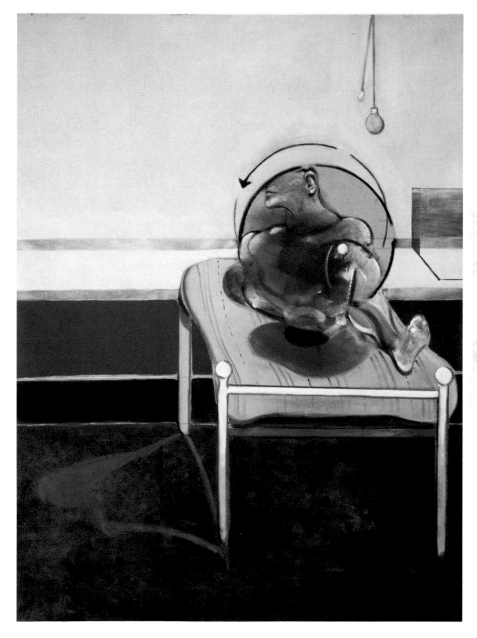

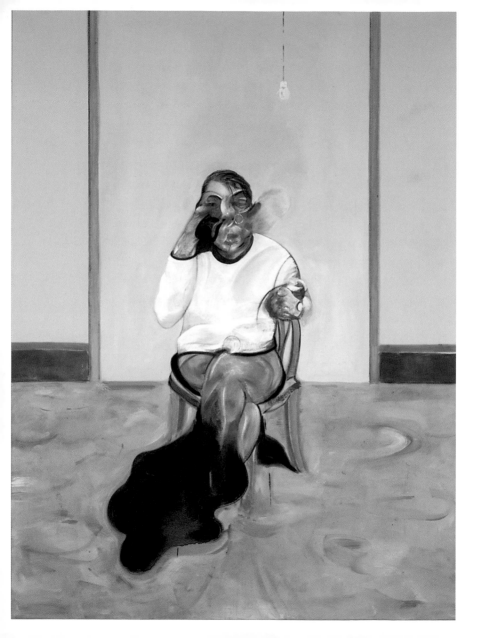

while his conversations with Sylvester were translated in French and published by the Swiss publisher Albert Skira. In the meantime his works were exhibited in Tokyo and Moscow. And despite the fact that he was considered the most important living artist and the media now treated him as a "phenomenon" and spoke of the "Bacon Myth", he continued to work in solitude and to travel. For example, in 1990, when he was already eighty-one, he decided to go to Madrid to see the major Velázquez exhibition.

It was not this visit to the Spanish capital that proved to be fatal, but the second one he made in 1992, when he thought he could regain a bit of vitality by making a journey.

Self-Portrait
from *Three Portraits*, 1973
Oil on canvas,
cm 198 × 147,5
The Museum of Modern
Art, New York, Gift
of Mr. and Mrs. William
A.M. Burden

Bacon, who always insisted he never deliberately tackled sacred themes for their religious value, had begun his artistic career with a Crucifixion, and had become famous with the representations of a pope, died five days after arriving in Spain, nursed in a clinic by two nuns.

Works

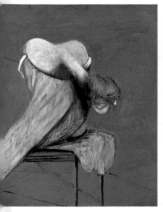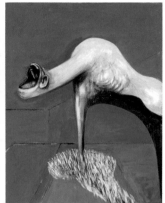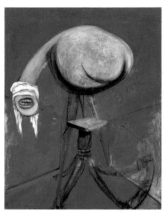

1. *Three Studies for Figures at the Base of a Crucifixion,* 1944

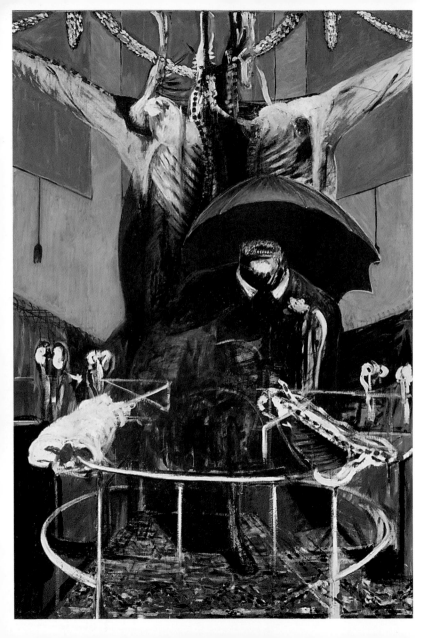

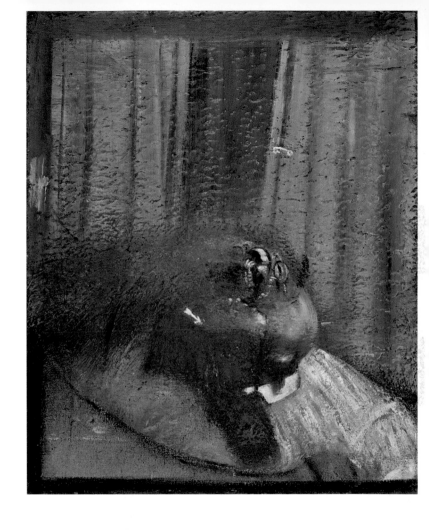

2. *Painting 1946*, 1946

3. *Head II*, 1949

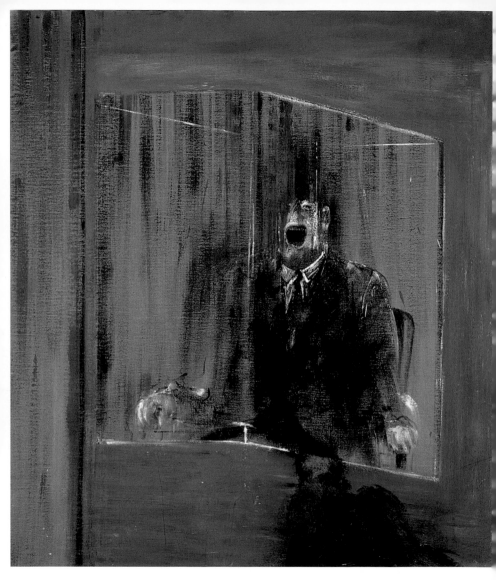

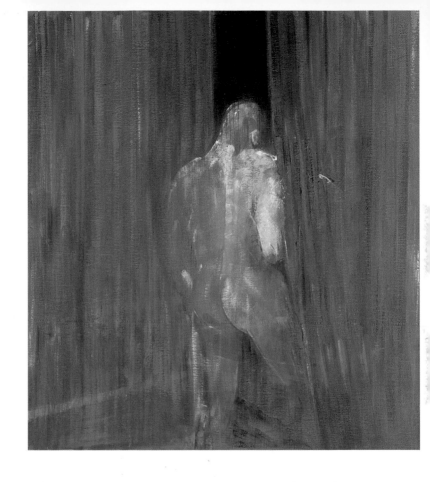

4. *Study for Portrait*, 1949

5. *Study from the Human Body*, 1949

Following pages
6. *Study after Velázquez*, 1950

7. *Untitled (Pope)*, 1950

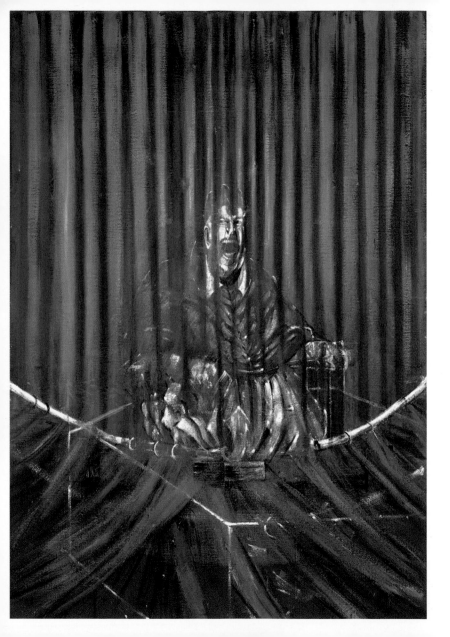

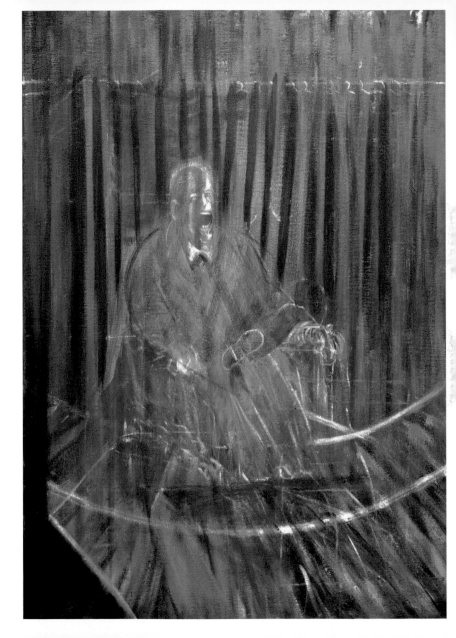

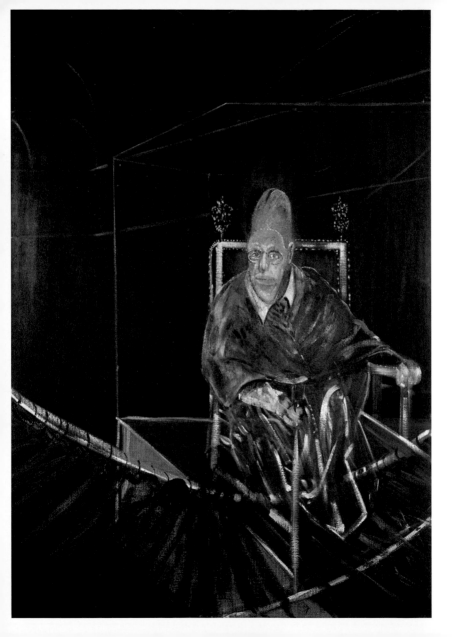

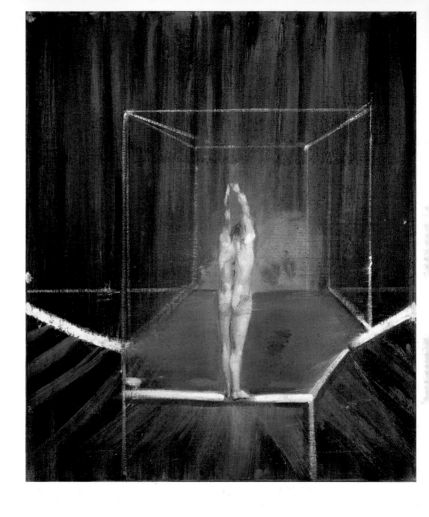

8. *Pope I*, 1951

9. *Study of a Nude*
(after Muybridge, *The Human
Figure in Motion*), 1952-53

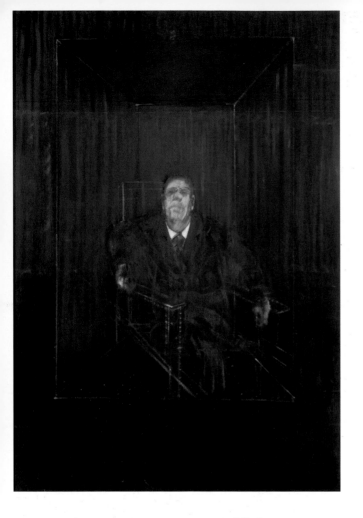

46

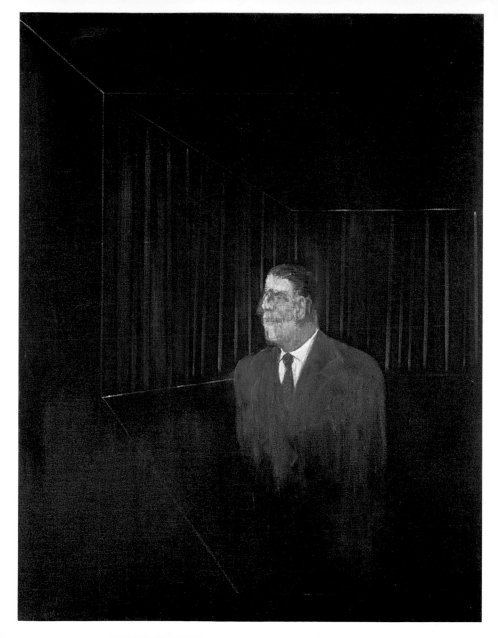

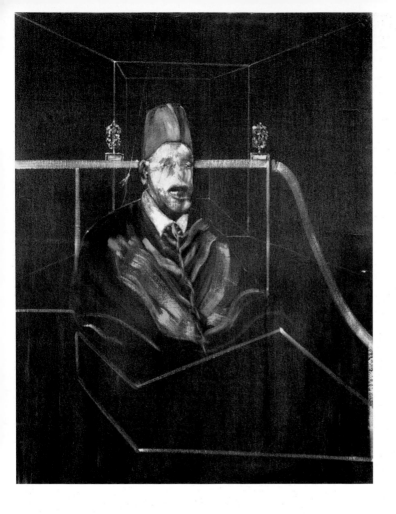

14. *Study for a Portrait VI,*
1953

15. *Study for a Portrait VII,*
1953

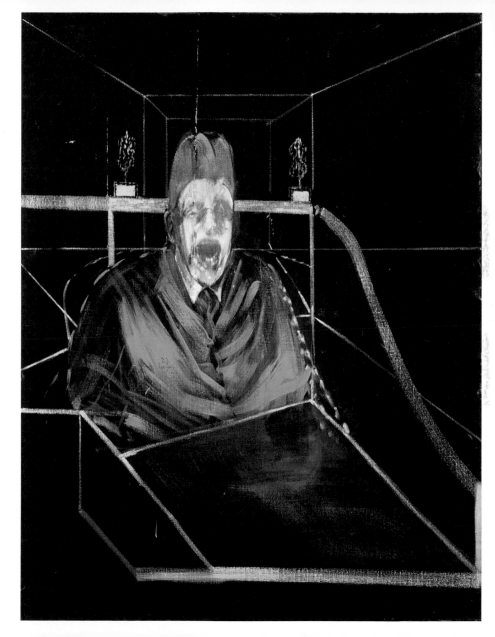

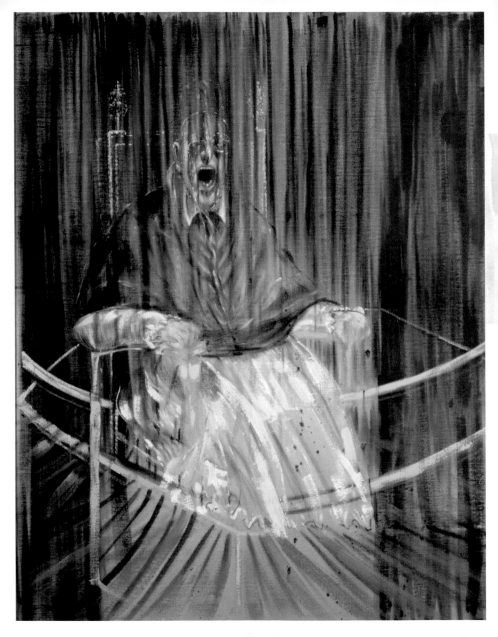

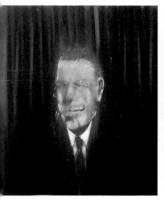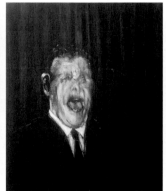

16. *Study after Velázquez's Portrait of Pope Innocent X,* 1953

17. *Three Studies of the Human Head,* 1953

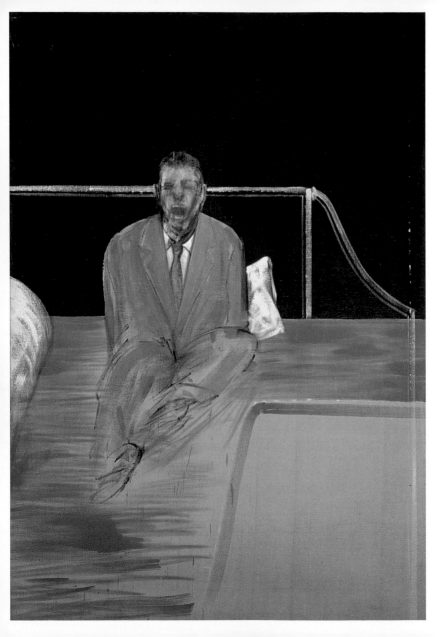

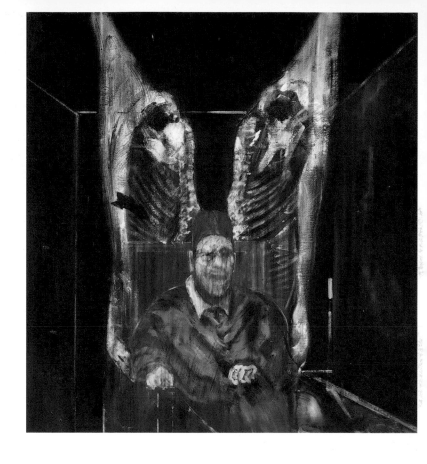

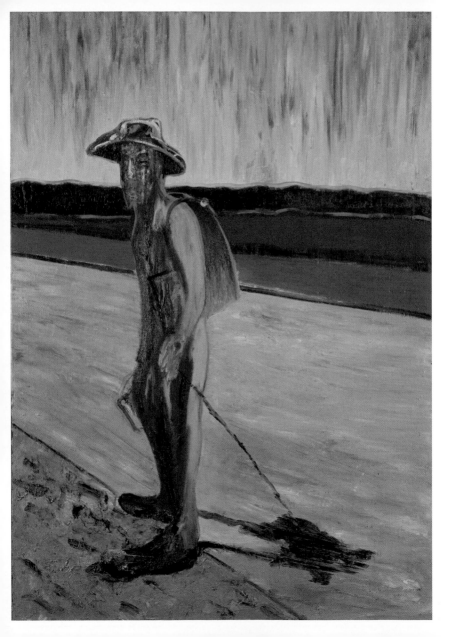

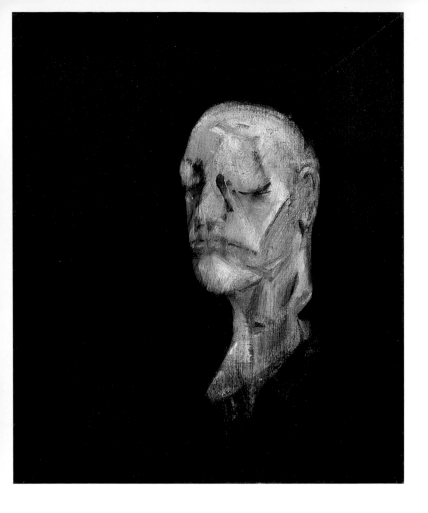

22. *Study for Portrait II
(after the Life Mask of William
Blake),* 1955

23. *Portrait of a Head,* 1959

58

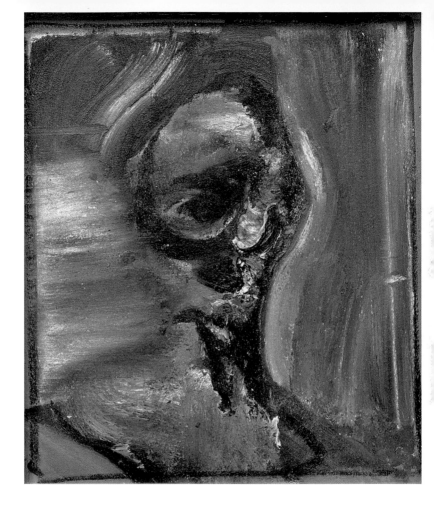

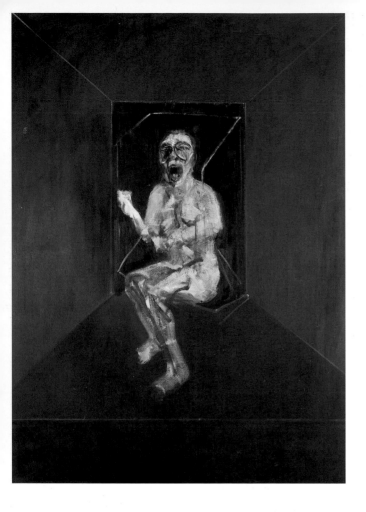

24. *Study for the Nurse
in the Film 'The Battleship
Potemkin',* 1957

25. *Seated Figure,* 1960

60

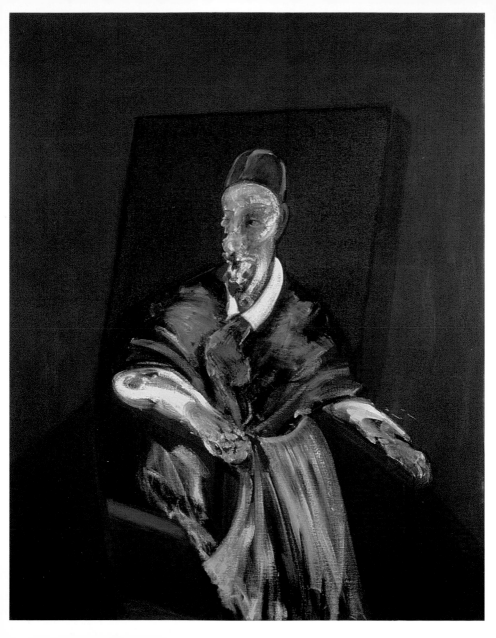

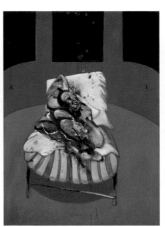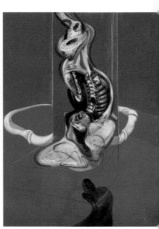

62

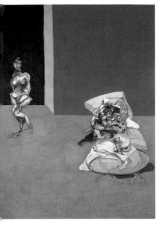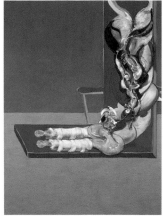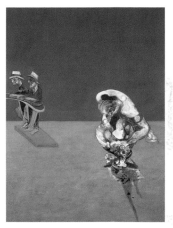

26. *Three Studies for a Crucifixion*, 1962

27. *Triptych – Crucifixion*, 1965

Following pages
28. *Woman Emptying a Bowl of Water – Paralytic Child on all Fours* (after Muybridge, *The Human Figure in Motion*), 1965

29. *Portrait of George Dyer Riding a Bicycle*, 1966

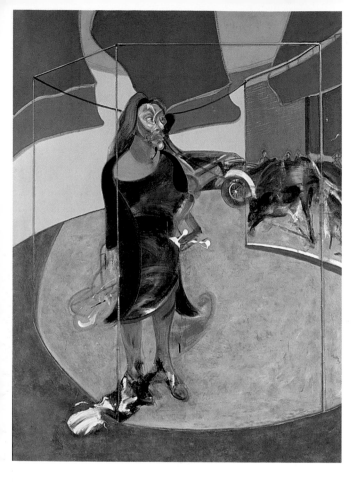

30. *Portrait of Isabel Rawsthorne Standing in a Street in Soho*, 1967

31. *Study of George Dyer in a Mirror*, 1968

Following pages
32. *Study for Bullfight no. 1*, 1969

33. *Study for Bullfight no. 2*, 1969

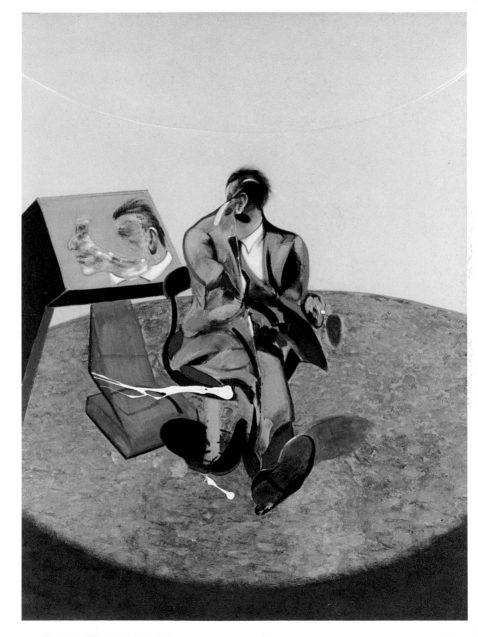

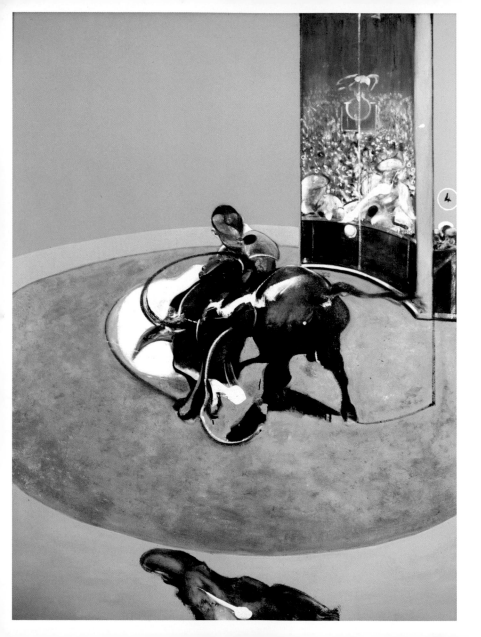

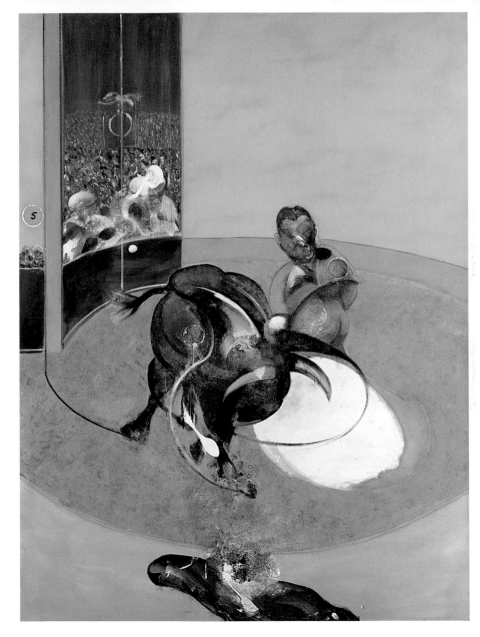

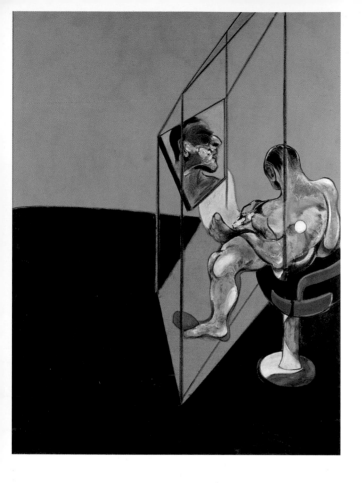

34. *Three Studies of the Male Back* (right-hand panel), 1970

35. *Study for Portrait*, 1971

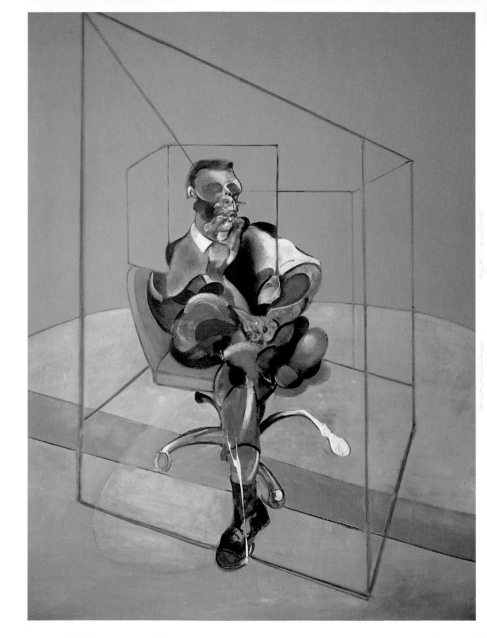

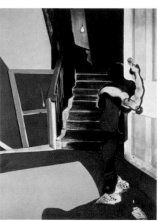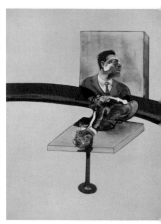

36. *Triptych – In Memory
of George Dyer*, 1971

37. *Three Studies of Figures
on Beds*, 1972

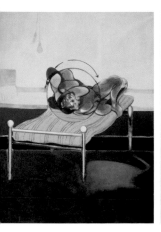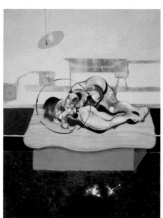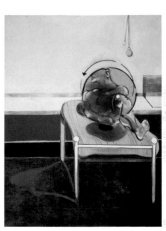

73

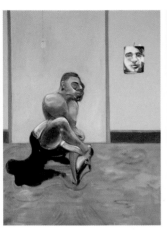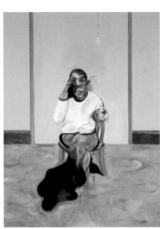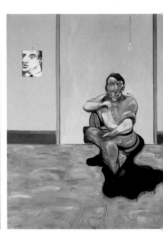

38. *Three Portraits·*
Posthumous Portrait of George
Dyer, Self-Portrait, Portrait
of Lucian Freud, 1973

39. *Sleeping Figure,* 1974

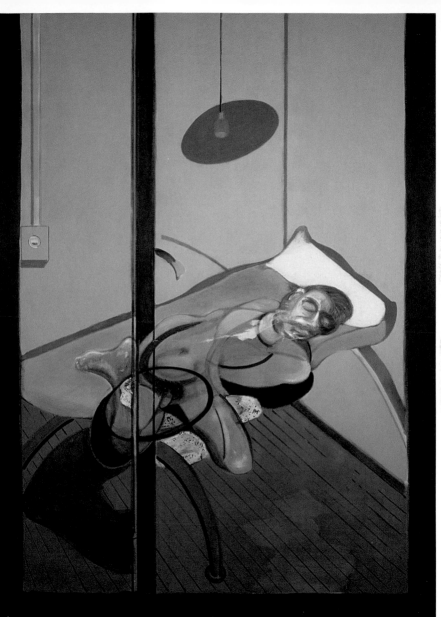

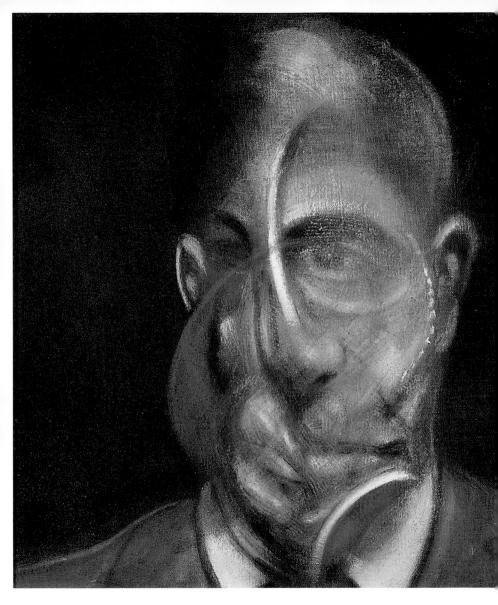

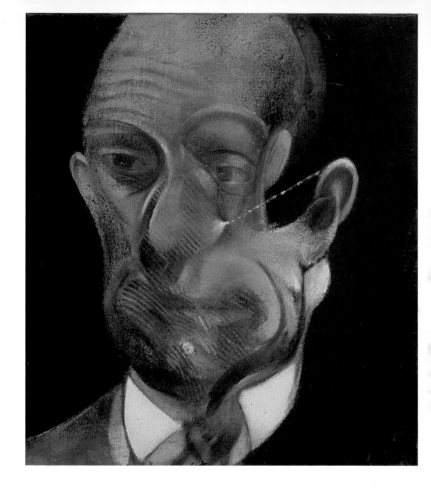

40. *Portrait of Michel Leiris,*
1976

41. *Study for Portrait
(Michel Leiris),* 1978

Following pages
42. *Painting 1978,* 1978

43. *Two Seated Figures,* 1979

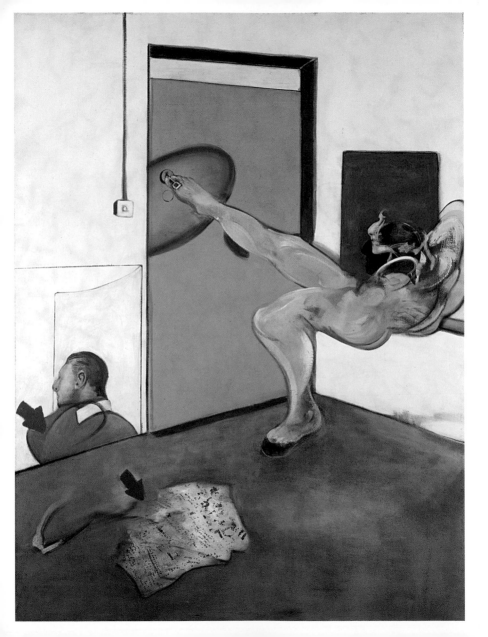

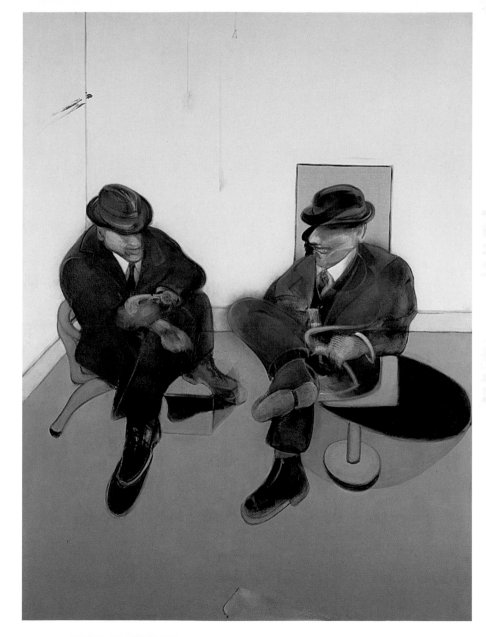

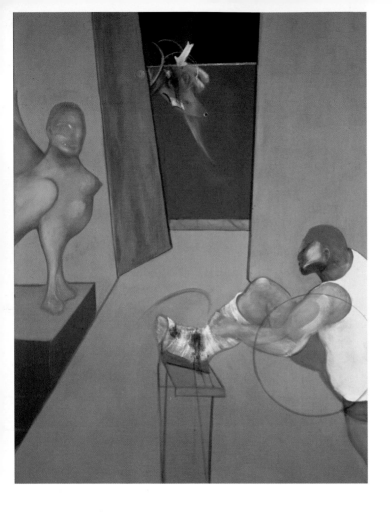

44. *Œdipus and the Sphinx
after Ingres*, 1983

45. *Sand Dune*, 1983

80

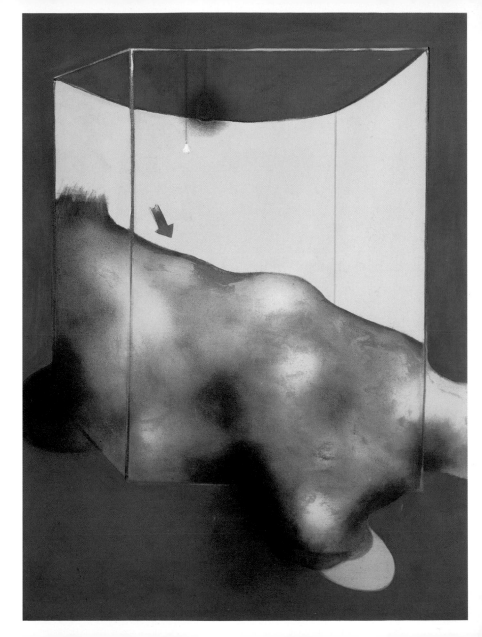

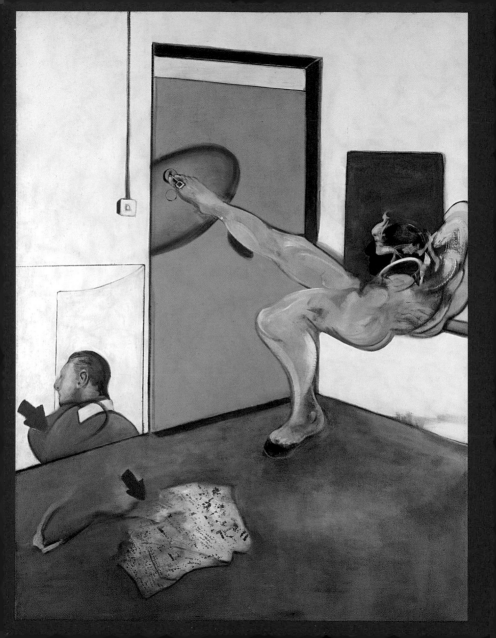

Selected Bibliography

R. Alley, *Francis Bacon, Catalogue raisonné*, London 1964

Francis Bacon. Recent Paintings, exhibition catalogue, London 1965

Francis Bacon, exhibition catalogue, Paris-Düsseldorf 1972

L. Trucchi, *Francis Bacon*, New York 1975

M. Leiris, *Francis Bacon, full face and in profile*, New York 1983 (translation of *Francis Bacon, face et profil*, 1983)

Francis Bacon, exhibition catalogue, London 1985

D. Ades, A. Forge, *Francis Bacon*, New York 1985

H.M. Davies, S. Yard, *Francis Bacon*, New York-London-Paris 1986

M. Archimbaud, *Francis Bacon in conversation with Michel Archimbaud*, London 1993

R. Chiappini (edited by), *Francis Bacon*, exhibition catalogue, Lugano 1993

D. Farson, *The Gilded Gutter Life of Francis Bacon*, London 1993

J. Russell, *Francis Bacon*, London 1993

A. Sinclair, *Francis Bacon. His Life and Violent Times*, London 1993

G. Deleuze, *Francis Bacon: The logic of sensation*, 1994 (translation of *Francis Bacon: Logique de la sensation*, 1981)

C. Vitali (edited by), *Francis Bacon. 1909-1992. Retrospektive*, exhibition catalogue, Munich-Paris 1996

M. Peppiatt, *Francis Bacon: Anatomy of an Enigma*, London 1997

Francis Bacon: Important Paintings from the Estate, exhibition catalogue, New York 1998

D. Sylvester (edited by), *Francis Bacon: The Human Body*, exhibition catalogue, London-Berkeley-Los Angeles 1998

E. Van Alphen, *Francis Bacon and the Loss of Self*, London 1998

D. Sylvester, *Interviews with Francis Bacon*, New York 1999

D. Sylvester, *Looking Back at Francis Bacon*, New York 2000

A. Brighton, *Francis Bacon. British Artists*, Londra 2001

H.M. Davies (edited by), *Francis Bacon. The Papal Portraits of 1953*, exhibition catalogue, San Diego 2001

Francis Bacon: Paintings, exhibition catalogue, New York 2002

Francis Bacon and the Tradition of Art, exhibition catalogue, Vienna-Riehen 2003

F. Marini (edited by), *Bacon*, "I Classici dell'Arte – Il Novecento", Milan 2004

M. Cappock, *Francis Bacon's Studio*, London 2005

M. Hammer, *Francis Bacon: Portraits and Heads*, Edinburgh 2005

M. Harrison, *In Camera, Francis Bacon: Photography, Film and the Practice of Painting*, London 2005

M. Peppiatt, *Francis Bacon in the 1950s*, London 2006

W. Schmied, *Francis Bacon: Commitment and Conflict*, London 2006

A. Zweite, *Francis Bacon: The Violence of the Real*, London 2006

R. Chiappini (edited by), *Bacon*, exhibition catalogue, Milan 2008

autonomy. It constitutes a new vision, of flesh and blood, instead of simply being a simulacrum, an indirect allusion to reality. The introspective process does not result solely in the ineluctability of the formal overturning, but finds a raison d'être also in the consequent profound transformation and in the regeneration that transmute the character of an exterior event into an interior experience through awareness and memory. Faced with the richness of existence worth fully being lived and without hypocrisy, the expressive urgency of Bacon's language, defined crude and brutal because of an excess of realism, is transformed into a striving for feeling. It becomes astonishment before a new world, beyond rules, hierarchies and genres.

The extraordinary intellectual lucidity of the Anglo–Irish artist has brought about strong images, pictures full of enigma, revealing themselves to be stronger than his voluntary isolation, his phobias of a man besieged, his restless, unquiet temperament. His desire to communicate has gone beyond his passionate excesses, his manias, his provocations. He has overcome his declared yet absolutely genuine desperation before the huge challenge of giving form to the stimuli of instinct, in the awareness that this was the only way to establish an underlying communication – that was not ephemeral – between men.

For Bacon, painting represents the recovery of man and of his centrality; it is above all an obsession about life, a torment of the flesh and spirit. He obeys the need to transfer to canvas the phantasms of a fragile and desperate existence, the primary and direct source of his image-filled universe. But even more significant is the perception of how his commitment as painter represents a form of catharsis, of redemption of everyday existence, of how underlying his work there has always been a striving to seek a difference – however small – between life and art to assure the latter an absolute testimonial value.

them – even more caricatural than I do in the ordinary way.

DS: Anyway, you don't have to. And it seems that the circumstances in which the artist works today suits you very well. You paint what you like to paint and your work goes to your gallery.

FB: That does suit me very well indeed, yes. My gallery don't bother me. I just work in isolation and when I have done something which I want to let go, they come and collect it. And they may sell it and they may not.

DS: That is to say, the whole set-up of society suits you and your attitude towards work?

FB: I want my life to be as free as possible, I just want the best kind of atmosphere to work in. And so in politics I have tended to vote for the Right because they are less idealistic than the Left and therefore one is left freer than one would be if encumbered by the idealism of the Left. I always feel that for me the Right is the best of a bad job.

DS: What do you think are the essential things that go to make an artist, especially now?

FB Well, I think that there are lots of things. I think that one of the thing is that, if you are going to decide to be a painter, you have got to decide that you are not going to be afraid of making a fool of yourself. I think another thing is to be able to find subjects which really absorb you to try and do. I feel that without a subject you automatically go back into decoration, because you haven't got the subject which is always eating into you to bring it back – and the greatest art always returns you to the vulnerability of the human situation. And then too, to be a painter now, I think that you have to know, even if only in a rudimentary way, the history of art from prehistoric times right up to today. You see, I have looked at everything in art. And also at many kinds of documentary books. I have

looked at books of wild animals, for instance, because those images excite me and every so often one of them may come up to me and suggest some way to use the human body; and there was a book that I bought years and years ago somewhere of images of filters – they were just filters of different kinds of liquids, but the way they were formed suggested all sorts of ways in which I could use the human body (after all, the human body is a in a sense a filter, apart from its other attributes). And I have also looked a great deal at the cinema. I was certainly, when I was much younger, influenced by the films of Eisenstein, and then after that I was very influenced by the films of Buñel, especially the early ones, because I think that he too had a remarkable precision of imagery. I can't say how they directly effected me, but they certainly have effected my whole attitude to visual things – by showing the acuteness of the visual image that you have got to make.

R. Chiappini
"Beauty Will Be Convulsed or Will Not Be" in *Bacon*, exhibition catalogue, Milan 2008
Like a flash of light in the dark, Bacon's works reveal – for an instant that defies the brevity of the moment – the brutality, violence and convulsive beauty of life. His gaze aims to block the unstoppable flow of existence and transform it into an absolute image. He wants to coagulate on the canvas the sense of an everyday nature that withdraws and becomes unfocused over time but is inevitable. An experienced image that cannot return to the darkness, that becomes a permanent revelation of the human condition.

In that revealing light, his painting, a medley of physicality and mental energy, becomes research and conquest of primitive images that impose through their own projected

it seems that Bacon uses painting to humiliate the bodies he paints. It seems that his brush is like a sharp scalpel, the colour a corrosive acid able to maim any skin, the sign a machine used to alter all substance. The word has become flesh, and the flesh drives him to his conviction. And it is as if painting wanted to anticipate, to force that conviction.

But behind the figure of this horror – which in some way makes the form of Nothingness visible to us, just as a shaking tree makes the form of the wind shaking it visible to us – looms the image of beauty. One is almost afraid to use this word in this context. But what other one could we use to describe the figure that, in the very moment in which we are about to give in to horror when observing a painting by Bacon, appears to us, grips and sustains us? And it does so not to console us, not to make us forget the terrible contradictions it has revealed, but in order to convince us, above all, of the power of our glance, in order to get us involved in sensitive knowledge that compensates for every outrage.

This figure of Beauty does not remove or conceal the figure of horror. That violet red remains as blood in our memory, and those whirling brushstrokes continue to disturb the painted faces and, through empathy, ours. But the painting system that gave rise to all that blood, to all those monstrosities, is so dense and transparent that we now feel that we know, and knowing, we feel we can dominate that which dominates us, we can master, in a form, that which materially masters us.

M. Zambon

Painting and the Crisis of Contemporary Man. Hopper and Bacon, 1998

Every moment of Bacon's existence (whether artistic or not) was characterized by excess and transgression. (…) One of Bacon's main objectives was therefore to express reality in all its violence by means of painting that springs from immediate sensation and, as he himself said, that represents the attempt to capture appearance with the body of sensations that this particular appearance stirred in him. Bacon's oeuvre is therefore not a mere objective transcription of things, but becomes a new reality unto itself, through which he forcefully communicates the excitement of contact with the most hidden strata of human nature, on which he wholly concentrates. This is why he states that it is so difficult to describe, and that one can only speak of one's own instincts and forget the rest.

D. Sylvester

Interviews with Francis Bacon, 1999

DS: You really are not working with any thought of an audience?

FB: I'm working for myself; what else have I got to work for? How can you work for an audience? What do you imagine that an audience would want? I have got nobody to excite except myself, so I am always surprised if anybody else likes my work sometimes. I suppose I'm very lucky, of course, to be able to earn my living by something that really absorbs me to try and do, if that is what you call luck.

DS: And your position is such that, of course, you hardly ever do a portrait on request.

FB: Not very often. Because most people want to be flattered by their portraits. It's a very odd thing about portraiture that people have an inbuilt idea of what they look like, of what they want to look like. If you deviate from that, they don't like it. Also, I like doing portraits of people I like – that I like as people and I like the look of. I would find it very difficult to do people that I really disliked. I suppose I could do caricatures of

and, allied with God knows what secret fury, the tender desperation of a man who is not unaware that he was once a child who could be astonished by almost everything. (…) According to Bacon, glass is a means whereby to "regularize" the material irregularities of the workmanship, but I still wonder whether its function is not also that of shaping to some degree the realistic virulence of these works or even imparting a sort of dignity to the presentation of these figures – caught by surprise, as it were, both in the warm misery of erotic commerce and in the banal poses of wakefulness or sleeping, not to speak of the coarser acts – that could be extended to the entire painting for that matter (including the flat background), and, thanks to almost literal absorption, of putting the finishing touches to a process of alienation and subtraction to everyday mentality, a process carried out in different ways in the case of some of its elements. Therefore, under the glass the canvases of Francis Bacon, at once so effervescent and controlled, offer to those who in one stroke embrace all their diversity, the surprising image of this singular contemporary artist in all its complexity.

G. Testori

"The Desperate Humanity of the Last of the Damned", in *Il Corriere della Sera*, 29 aprile 1992
The chairs, always equal to one another, in which he petrified his portraits with grimaces that detracted nothing from the physical likeness, and the portraits, which were also always or almost always the same and in any case were closely related to the desperate and convulsive conditions of life. Those chairs, I was saying, just like the beds that were the arena of the embraces-cum-clashes of his triumphant and implacable homosexual eros, were somewhat like the operating tables on which adept physicians performed ritual and regular vivisections. But those chairs, those armchairs, and those beds also had something definitive about them that transformed every horror into brilliance. That is, they had something in common with the high-backed chairs of the blessed that the great fresco painters of the past painted in their "Last Judgements".
I have already said this: Bacon never deluded himself that some form of redemption could exist, the only exception being the one that art could provide with its images of pain, terror and, often, disgust – in his case, the astounding beauty of his painting.

G. Deleuze

Francis Bacon: The logic of sensation, 1994
The body is a Figure, not a structure. Inversely the Figure, being a body, is not a face, nor does it have a face. However, it has a head, because the head is an integral part of the body. And it can even end up as a head. As a portraitist Bacon is a painter of heads, not of faces. There is a great difference between the two, for the face is a structured spatial organization that covers the head, while the head is an appendix of the body, although it is its apex. (…) Therefore, as a portraitist Bacon pursues a very special project: decompose the face, and find the head under the face or make it emerge therefrom.

E. Tadini

"Bacon, Beauty Begins with the Terrible", in *Il Corriere della Sera*, 2 July 1996
One speaks of the representation of horror in the painting of Bacon, the representation of the deterioration of the body under the daily action of Nothingness. He himself said that he wanted to depict the "vulnerability" of the human body and that life, from birth to death, is a long process of destruction. (…) At times

say that, if the great Spanish artist had not been blocked by respect for conventions, he would have discovered the *true* figure of the Pope. In reality, however, Bacon's procedure is more complicated: one can easily see that he has interpreted Velázquez *à la* El Greco, that is, in the manner of precisely that artist whose ascetic tendency to sublimation Velázquez had opposed with his own lucid and objective concept of reality. What does Bacon want to demonstrate by this (whether consciously or not, is of no matter)? That if one applies to reality (Velázquez's reality) the mysticism of sublimation and ecstasy, reality, instead of being "spiritualized", rots, immediately becomes putrefied, loathsome and repugnant. But why then does one speak of the "sublime"? Because of the supreme hypocrisy of the society we live in: the "sublime" of our age is really the contrary of the "sublime", is the horrible. So it is absurd to use the expression "new figuration" with regard to Bacon's deliberate, atrocious "defiguration", which involves the "figure" only to devalue it, degrade it, destroy it before the amazed eyes of the viewer. Discovering in the art of Bacon a rebirth of the figure would be like noting a "new humanism" in the novels or theatre of Beckett, who in a certain sense could be considered his literary parallel.

M. De Micheli

Images and the Anxiety of Civilizations, 1982
Bacon is (…) without a doubt one of the contemporary artists most engrossed in the late bourgeois cultural crisis. But his consciousness of its negativity is quite intense, and this intense consciousness is filled with an emotional tension that imparts the violent value of an antidote to his images. In other words, through the power of his images the negativity defines itself and materializes. Thus, consciousness of negativity implicitly

becomes a criticism of negativity. Violence, psychological shock, biological anguish, terror, horror and obsession – indeed, every motif of Bacon's vision and visionariness – lives inside his images a bitter, "rational" redemption. This fact makes any encounter with Bacon a tough but not fruitless event. Bacon is never submissive, weak or docile. He sometimes verges on cynicism, but his painting is always the result of painful and constant concentration on human existence, even when he shows spine-chilling ferocity. And this is the reason behind his vitality, due to which the negative becomes its opposite without losing any of the terrible marks of its true nature and origins. To use the definition that Walter Benjamin gave to Baudelaire, Bacon therefore becomes a sort of "secret agent in the enemy's ranks".

M. Leiris

Francis Bacon, full face and in profile, 1983
An Orestes whose Furies have just been appeased. A Hamlet who regains his composure after his encounter with his father's ghost. (…) A Maldoror half-angel and half-ogre who takes a breather after having uttered his long blasphemous *Songs*. A Falstaff who at one moment is jovial and is then absorbed in his thoughts, and whose excesses have seemingly left almost as young as he was when a page in the service of the Duke of Norfolk; and, zooming in on our disturbing present, a gambler with an elegantly modern profile whom we think we can catch in the instant that no clock is able to determine, when he stakes all his winnings in a game of dice, cards or roulette (…); rosy like an eighteenth-century empiricist philosophizing with a glass of brandy or sherry in his hand, the shaven, chubby and tormented face of Francis Bacon seems to reflect the eye-opening amazement, the intelligent tenacity

always proportionate to the intensity of its poetics. An artistic language is made up of elements that are culturally inherited, adopted outside the scope of the poetics that sparked its gestation, and of further, created elements; creative grafting, which naturally modifies this cultural contribution and produces a synthesis, is determined and conditioned by the degree of vitality of the new poetics. (…) The terrifying and macabre tone of Bacon's pessimistic vision of modern man has British roots. Bacon feels and perceives in terms of existentiality, that is as a daily torment, that aesthetic of the sublime that Burke had theorized in the mid-1700s, based on the sense of the horrible, the sinister, the gloomy. In order to gain a better understanding of Bacon's men-cum-orangutans and of the appalling void that imprisons them, let us consider the passage in William Blake's *The Marriage of Heaven and Hell* describing an infernal vision: "'Here', said I, 'is your lot, in this space, if space it may be call'd. (…) it was a deep pit, into which I descended (…) driving the Angel before me, soon we saw seven houses of brick; one we enter'd; in it were a number of monkeys, baboons, & all of that species, chain'd by the middle, grinning and snatching at one another, but withheld by the shortness of their chains: however, I saw that they sometimes grew numerous, and then the weak were caught by the strong, and with a grinning aspect, first coupled with, & then devour'd, by plucking off first one limb and then another till the body was left a helpless trunk; this after grinning & kissing it with seeming fondness they devour'd too (…).

G.C. Argan
Modern Art, 1770-1970, 1970
Bacon, the last heir of the "sublime", sublimes but does not idealize: therefore, the "sublime" for him is not the superhuman but rather the

sub-human, not the sacred or divine, but the demoniacal. His entire oeuvre shows that he does not believe in the election or salvation of humanity, but rather in its degradation or fall. Painting as well is therefore not an elective process but a degrading one. As such it is demystification, the brutal discovery of the truth that lies underneath pretence. It deliberately departs from the lines of research of modern art and links up with some of the best painters of the past, Velázquez or El Greco, which, however, Bacon does not use as models but as objects of critical analysis: he wants to demonstrate that if those artists had taken their art to its logical conclusion the results would have been much different. For example, in a series of six paintings Bacon analyzed Velázquez's *Portrait of Innocent X*. He shifts the figure toward the right in order to have it flow along the perspective of the back of the chair and make it appear "elusive". He eliminates the ornaments of the Pope's throne, transforming it into a gloomy box in perspective that materializes the black empty space of the background, imprisoning the figure. Having thus severed all relations of equilibrium with the backdrop, the figure becomes deformed, as if only that precarious and difficult relationship with space could give it a human appearance. However, Bacon in fact confines himself to exaggerating and weighing down the pictorial motifs of the original. For example, he transforms the luminous hues on the eyebrows and cheekbone into a livid and whirling halo around the eye, reverses the direction of the nose, and twists the moustache, the mouth and the chin to the opposite side. In other words, he *disfigures* Velázquez's figure; he changes the expression from strong to weak, from strong-willed to astute, from severe to wicked. But he does so by following Velázquez's procedure step by step, as if to

Critical Abstracts

L. Carluccio

"*Bacon, the Power and the Glory*", in *Bacon*, 1962

The oeuvre of Francis Bacon is extremely different, both in its obvious and secret origins and in the way it appears on the surface of the world of visible things. It is different because Bacon's figures tear themselves away from us with the same violence with which they reveal they want to assault us. Here we are not confronting the devil, but crude images that with terrible intuition define the undercurrent of Man, his nervous tension, his capacity to suffer with his eyes wide open. Thus, there are images that invite us to a spectacle that may at first glance appear to be brutal and bitter, but whose brutality is yet to be discovered on another level, since it does not belong to the open gestures of the images but rather to the secret characterization of their nature. (…) Bacon lends substance to the doubts and anguish of our time. Perhaps it is the only sincere aspect of the anguish of our time, and while we realize that through the painter's images this anguish is nourished basically by excessive affiliation with human fragility, we must admit that this fragility is the other necessary and inseparable side of strength, just as fear is the other facet of courage, the victim of the tormentor, slavery of power, and infamy of glory. This is why Bacon's art is in such utter contrast to the confidence that modern technological man displays in his capacity to wholly dominate nature and events. In fact, the artist even seems to suggest that such confidence is nothing but a mask, a new mask that covers the uneasiness that lies in the depths of our being. (…) In any case, it is difficult to find other figures that represent the fall of man like those created by Bacon, beings that are defeated, overcome, disheartened and furiously impotent – and annoyed by their impotence. Bacon's cynicism with regard to man's destiny seems even more cruel because the artist not only represents his fall in its final and irreversible moment, but describes its progressive degradation. Bacon's figures are actually unable to harm or offend, precisely because they are sadly consuming their strength. Their anguish is all the more tense and tragic, because in their impotence they drag along the memory of their former strength, which others like them may still possess.

M. Calvesi

"A Comparison: Bacon and Jorn", in *Le due avanguardie*, 1966

It is a well-known fact that in Bacon the elaboration of the pictorial image is often mediated by a pre-existing image: a painting by an Old Master (Velázquez's *Portrait of Innocent X*), or by a modern artist (Van Gogh), a photograph or a filmed sequence. (…) Bacon's meditative procedure is one that basically conditions the formation of his image and his artistic idiom. (…) Despite the undeniable parallelism of his aesthetic with the existential aesthetic of Art Informal, Bacon has more "punch" regarding the present instances of "new figuration" (granting this term its necessary hypothetical scope and excluding those mediocre attempts at would-be "new figuration" that often spring from an equally mediocre misunderstanding of Bacon's art). This would seem to demonstrate once again that the formal unity, the unified orchestration of style can operate beyond the range of the aesthetic in which it materializes. But it is also true that the efficacy of the artistic idiom is

	Life of Bacon	Historical events
1954	Bacon visits Ostia and Rome, but not Venice, where some of this works are exhibited at the Biennale.	
1956	Sojourn in Tangier with his friend Peter Lacy; here he meets many Beat writers. First self-portrait.	In the URSS the de-Stalinization process begins. Revolts in Poland and Hungary. Lloyd Wright beings construction of the Solomon R. Guggenheim Museum in New York.
1960	The exhibition at the Marlborough Fine Arts Gallery in London enjoys a great success.	John Fitzgerald Kennedy elected President of the United States.
1965	The Crucifixion triptych. Bacon meets Michel Leiris, with whom he has a long friendship.	Malcolm X assassinated. First exhibition of Op Art at the MoMA.
1971	Bacon's mother dies. Just before the inauguration of his first one-man show in Paris, his friend George Dyer commits suicide. Paints the triptych *In Memory of George Dyer*.	Andy Warhol executes the cover of the album *Sticky Fingers* for the Rolling Stones.
1977	The one-man show held at the Galerie Claude Bernard in Paris is a success. At Rome he meets Balthus.	
1983	First exhibition in Japan.	Nobel Peace Prize awarded to Lech Walesa.
1987	Exhibition in the Galerie Lelong in Paris: the critics speak of the "Bacon Myth".	Disarmament agreement between the USA and URSS. Warhol dies.
1990	Visits the Velázquez exhibition at the Prado. Michel Leiris dies.	The Berlin Wall is torn down and Germany is reunified.
1991	Bacon paints *Studies of the Human Body*, with his friend John Edwards, who later became his heir, as the model. The Tate Gallery dedicates an entire hall to his works.	The Gulf War. Slovenia and Croatia declare their independence: Serbian military intervention.
1992	In April he catches pneumonia in Madrid and dies six days later of a heart attack.	

	Life of Bacon	**Historical events**
1909	Francis Bacon is born in Dublin on October 28 of English parents.	The Futurist Manifesto in Paris. Marconi awarded the Nobel Prize in Physics.
1914	The family moves back and forth between London and Ireland. Bacon has no regular schooling.	The Sarajevo assassination triggers the First World War.
1926	Because of an argument with his father, Francis leaves the family and goes to London.	Rilke dies. Hirohito becomes Japanese emperor.
1927	His father puts Francis under the tutelage of a relative, Harcourt-Smith, with whom the young man spends some time in Berlin. At Paris he begins painting after having seen an exhibition of Picasso's works.	
1929	Francis returns to London, where he works as an interior decorator and designer. His first paintings are strongly influenced by Cubism and Surrealism.	The Wall Street crash marks the beginning of the Great Depression.
1933	He paints his first masterpieces, including some *Crucifixions*.	Hitler elected Chancellor of Germany; the Reichstag fire and the abrogation of the republican constitution.
1937	Together with Victor Pasmore, Roy de Maistre and Graham Sutherland, Bacon participates in the "Young British Painters" show held at the Agnew and Sons Gallery in London. His father dies.	Picasso: *Guernica*. The National Gallery founded in Washington, DC.
1944	Bacon finished the triptych *Three Studies for Figures at the Base of a Crucifixion*.	Rome and Paris are liberated. Death of Kandinsky.
1948	*Painting 1946* is sold to the New York Museum of Modern Art.	Foundation of the state of Israel. Gandhi assassinated.
1950	He takes part in several exhibitions, and travels in Africa. Meets the art critic Sylvester.	

25. *Seated Figure*, 1960
Oil on canvas, 152.2 x 118 cm
Private collection

26. *Three Studies
for a Crucifixion*, 1962
Oil and sand on canvas,
198.2 x 144.8 cm each
Solomon R. Guggenheim Museum,
New York

27. *Triptych – Crucifixion*, 1965
Oil on canvas, 198 x 147.5 cm
for each of 3 elements
Pinakothek der Moderne, Munich

28. *Woman Emptying a Bowl
of Water – Paralytic Child
on all Fours* (after Muybridge,
The Human Figure in Motion),
1965
Oil on canvas, 198 x 147.5 cm
Stedelijk Museum, Amsterdam

29. *Portrait of George Dyer Riding
a Bicycle*, 1966
Oil on canvas, 198 x 147.5 cm
Fondation Beyeler, Riehen-Basel

30. *Portrait of Isabel Rawsthorne
Standing in a Street in Soho*,
1967
Oil on canvas, 198 x 147.5 cm
Neue Nationalgalerie, Staatliche
Museen zu Berlin, Berlin

31. *Study of George Dyer
in a Mirror*, 1968
Oil on canvas, 198 x 147.5 cm
Museo Thyssen-Bornemisza,
Madrid

32. *Study for Bullfight no. 1*, 1969
Oil on canvas, 198 x 147.5 cm
Private collection

33. *Study for Bullfight no. 2*, 1969
Oil on canvas, 198 x 147.5 cm
Musée des Beaux-Arts, Lyons

34. *Three Studies of the Male
Back* (right-hand panel), 1970
Oil on canvas, 198 x 147.5 cm
Kunsthaus, Vereinigung Zürcher
Kunstfreunde, Zurich

35. *Study for Portrait*, 1971
Oil on canvas, 198 x 147.5 cm
Private collection

36. *Triptych – In Memory
of George Dyer*, 1971
Oil on canvas,
198 x 147.5 cm each
Fondation Beyeler, Riehen-Basel

37. *Three Studies of Figures
on Beds*, 1972
Oil and pastel on canvas,
198 x 147.5 cm each
Private collection

38. *Three Portraits: Posthumous
Portrait of George Dyer,
Self-Portrait, Portrait
of Lucian Freud,* 1973
Oil on canvas,
198 x 147.5 cm each
Private collection

39. *Sleeping Figure*, 1974
Oil on canvas, 198 x 147.5 cm
Private collection

40. *Portrait of Michel Leiris*, 1976
Oil on canvas, 34 x 29 cm
Musée national d'Art moderne,
Centre Georges Pompidou, Paris,
Gift of Louise and Michel Leiris

41. *Study for Portrait
(Michel Leiris)*, 1978
Oil on canvas, 35.5 x 30.5 cm
Musée national d'Art moderne,
Centre Georges Pompidou, Paris,
Gift of Louise and Michel Leiris

42. *Painting 1978*, 1978
Oil on canvas, 198 x 147.5 cm
Private collection

43. *Two Seated Figures*, 1979
Oil on canvas, 198 x 147.5 cm
Private collection

44. *Œdipus and the Sphinx
after Ingres*, 1983
Oil on canvas, 198 x 147.5 cm
Sintra Museum of Modern Art,
The Berardo Collection, Lisbon

45. *Sand Dune*, 1983
Oil on canvas, 198 x 147.5 cm
Fondation Beyeler, Riehen-Basel

Catalogue
of the Works

1. *Three Studies for Figures
at the Base of a Crucifixion*, 1944
Oil and pastel on cardboard,
94 x 74 cm each
The Tate Gallery, London

2. *Painting 1946*, 1946
Oil and tempera on canvas,
198 x 132 cm
The Museum of Modern Art,
New York

3. *Head II*, 1949
Oil on canvas, 80.5 x 65 cm
Ulster Museum, Belfast

4. *Study for Portrait*, 1949
Oil on canvas, 147.3 x 130.8 cm
The Museum of Contemporary Art,
Chicago

5. *Study from the Human Body*,
1949
Oil on canvas, 147.5 x 131 cm
National Gallery of Victoria,
Melbourne

6. *Study after Velázquez*, 1950
Oil on canvas, 198 x 137.2 cm
The Estate of Francis Bacon,
London

7. *Untitled (Pope)*, 1950
Oil on canvas, 198 x 137.2 cm
The Estate of Francis Bacon,
London

8. *Pope I*, 1951
Oil on canvas, 197.8 x 137.4 cm
City Art Gallery and Museum
Collections, Aberdeen

9. *Study of a Nude*
(after Muybridge, *The Human
Figure in Motion*), 1952-53
Oil on canvas, 61 x 51 cm
University of East Anglia,
Sainsbury Centre for Visual Arts,
Norwich

10. *Study for a Portrait*, 1953
Oil on canvas, 197 x 137 cm
The Hess Collection, Napa

11. *Man in Blue II*, ca. 1953
Oil on canvas, 152 x 117 cm
Collection Galerie Beyeler, Basel

12. *Study for a Portrait II*, 1953
Oil on canvas, 152.7 x 116.9 cm
The Collection of Samuel and
Ronnie Heyman, New York

13. *Study for a Portrait V*
(*Cardinal V*), 1953
Oil and sand on canvas,
152.7 x 117.1 cm
Hirshhorn Museum and Sculpture
Garden, Smithsonian Institution,
Washington, Gift of the Joseph H.
Hirshhorn Foundation

14. *Study for a Portrait VI*, 1953
Oil on canvas, 152 x 117 cm
Institute of Arts, Minneapolis

15. *Study for a Portrait VII*, 1953
Oil on canvas, 152.3 x 117 cm
The Museum of Modern Art, New
York, Gift of Mr. and Mrs. William
A.M. Burden

16. *Study after Velázquez's
Portrait of Pope Innocent X*, 1953
Oil on canvas, 153 x 118 cm
Des Moines Art Center, Des
Moines, The Nathan Emory Coffin
Collection

17. *Three Studies of the Human
Head*, 1953
Oil on canvas, 61 x 51 cm
Private collection

18. *Study for Figure II*,
1953-1955
Oil on canvas, 198 x 137 cm
The Collection of Mr. and Mrs.
J. Tomilson Hill, New York

19. *Figure with Meat*, 1954
Oil on canvas, 129.9 x 121.9 cm
The Art Institute, Chicago

20. *Study for Portrait
of Van Gogh V*, 1957
Oil and sand on canvas,
198 x 142 cm
Hirshhorn Museum and Sculpture
Garden, Smithsonian Institution,
Washington, Gift of the Joseph
H. Hirshhorn Foundation

21. *Study for Portait
of Van Gogh VI*, 1957
Oil on canvas, 198.1 x 142.2 cm
Arts Council Collection and
Hayward Gallery, London

22. *Study for Portrait II*
(*after the Life Mask of William
Blake*), 1955
Oil on canvas, 60 x 51 cm
Private collection

23. *Portrait of a Head*, 1959
Oil on canvas, 38.1 x 31.7 cm
The Collection of Franklin and
Susanne Konigsberg, New York

24. *Study for the Nurse in the Film
'The Battleship Potemkin'*, 1957
Oil on canvas, 198 x 142 cm
Städelsches Kunstinstitut,
Frankfurt

Appendix